CW00551282

HEARTENING THE SOUL

Surround Yourself With The Energy To Revitalize

Jeanne Fleming

Table of Contents

Chapter 1: You're Good Enough 6

Chapter 2: The Power of Contentment 9

Chapter 3: The Magic of Journaling 12

Chapter 4: When To Listen To That Voice Inside Your Head 15

Chapter 5: Understanding Yourself 18

Chapter 6: Things That Spark Joy 20

Chapter 7: Top Life regrets of Dying Hospital Patients 23

Chapter 8: Why You Are Setting The Wrong Goals 26

Chapter 9: The Problem With Immediate Gratification 29

Chapter 10: How To Stop Worrying About Failure 34

Chapter 11: How To Deal With Feelings of Unworthiness 37

Chapter 12: Enjoying The Simple Things 41

Chapter 13: Having a Balanced Life 43

Chapter 14: How To Worry Less 46

Chapter 15: Don't Overthink Things 50

Chapter 16: The Trick To Focusing 52

Chapter 17: Learning To Trust Others 55

Chapter 18: *What To Do When You Feel Like Your Work is not Good Enough* 58

Chapter 19: *Don't Set The Wrong Goals* 61

Chapter 20: Get in the Water (Stop wasting time) 64

Chapter 21: Work Harder Than Everybody Else 66

Chapter 22: Being 100% Happy Is Overrated 69

Chapter 23: Dealing With Difficult People 72

Chapter 24: Discomfort Is Temporary 76

Chapter 25: It's Okay To Feel Uncertain 79

Chapter 26: Saying Yes To Things 82

Chapter 27: Planning Ahead 87

Chapter 28: How To Improve Your Communication Skills 90

Chapter 29: How To Crush Your Goals This Quarter 93

Chapter 30: Overcoming Your Fears ... 96

Chapter 31: Take Ownership of Yourself ... 99

Chapter 32: The Difference Between Professionals and Amateurs ... 101

Chapter 33: How To Start Working Immediately 104

Chapter 34: 7 Ways To Know When It's Time To Say Goodbye To The Past .. 108

Chapter 1:

You're Good Enough

People come and say 'I did something stupid today. I am so bad at this. Why is it always me?' You will acknowledge even if no one else says it, we often say it to ourselves.

So what if we did something stupid or somewhat a little awkward. I am sure no one tries to do such things voluntarily. Things happen and sometimes we cause them because we have a tendency to go out of our way sometimes. Or sometimes our ways have a possibility of making things strange.

It doesn't make you look stupid or dumb or ugly or less competent. These are the things you make up of yourself. I am not saying people don't judge. They do. But their judgment should not make you think less of yourself.

No matter how much you slip up, you must not stop and you must not bow down to some critique. You only have to be a little determined and content with yourself that you have got it alright.

You need to realize your true potential because no matter what anyone says, you have what it takes to get to the top.

Need some proof? Ask yourself, have you had a full belly today? Have you had a good night's sleep last night? Have you had the will and energy to get up and appear for your job and duties? Have you had the guts to ask someone out to dinner because you had a crush on them?

If you have a good answer to any of these questions, and you have done it all on your own with your efforts. Congratulations my friend, you are ready to appraise yourself.

You have now come to terms with your abilities and you don't need anyone else's approval or appraisal. You don't depend on anyone either psychologically or emotionally.

So now when the times get tough you can remind yourself that you went through it before. And even if you failed back then, you have the right energy and right state of mind to get on top of it now. You are now well equipped to get ahead of things and be a better person than you were the last time.

You are enough for everything good or not so good happening in and around you.

Your health, your relations, your carrier, your future. Everything can be good and better when you have straightened out your relationship with yourself. When you have found ways to talk to yourself ad make yourself realize your true importance. When you learn to admire yourself.

Once you learn to be your best critic, you can achieve anything. Without ever second-guessing yourself and ever trying to care for what anyone else will think.

If you find yourself in a position where you had your heart broken but you still kept it open, you should have a smile on your face. Because now you might be on your path to becoming a superior human being.

Chapter 2:

The Power of Contentment

Today we're going to talk about why contentment is possibly a much more attainable and sustainable alternative than trying to achieve happiness.

As we have briefly gone through in the previous video, happiness is a state of mind that is fleeting and never truly lasts for too very long before the opposing forces of sadness and feelings of boredom start creeping in.

Happiness is a limited resource that needs energy and time to build, and we can never really be truly happy all the time. But what about the notion of contentment?

Contentment is a state of feeling that you are satisfied with the current situation and it need not go beyond that. When we say we are contented with our circumstances, with our jobs, with our friends, family, and relationships, we are telling ourselves that we have enough, and that we can and should be grateful for the things we have instead of feeling lacking in the things we don't.

Many a times when i ask myself if i am happy about something, be it a situation that I had found myself in, or the life that I am living, majority

of the time the answer is a resounding no. And it is not because I am unhappy per se, but if i were to ask myself honestly, I can't bring myself to say that yes absolutely that all is great and that I am 100$% truly happy with everything. I have to say that this is my own personal experience and it may not be an accurate representation of how you see life.

However, if i were to reframe and ask myself this question of "Am I Contented with my life?" I can with absolute confidence say yes I am. I may not have everything in the world, but i can most definitely say I am contented with my job, my friends, my family, my career, my relationships, and my health and body. That I do not need to keep chasing perfection in order to be contented with myself.

You will find that as you ask yourself more and more if you are contented, and if the answer is mostly a yes, you will gradually feel a shift towards a feeling that actually life is pretty good. And that your situation is actually very favourable. Yes you may not be happy all the time, but then again who is? As long as you are contented 90% of the time, you have already won the game of life. And when you pair contentment with a feeling of gratefulness of the things you have, you will inevitably feel a sense of happiness without having to ask yourself that question or be trying to chase it down on a daily basis.

Many a times when I looked at my current situation to see if I was on the right track, I look around me and I feel that whilst there may be areas that I am lacking and certainly needs improvement, in the grand scheme of things, I am pretty well off and i am contented.

So I challenge all of you today to look at your life in a different perspective. Start asking yourself the right question of "are you contented", and if by any chance you are not majority of the time, look at what you can do to change things up so that you do feel that life is indeed great and worth living.

Chapter 3:
The Magic of Journaling

Today we're going to talk about the power of journaling, and why you should start making it as part of your daily habit starting today.

Everyday, every second of our lives, we are bombarded with things coming at our way. From our colleagues, our bosses, to our friends, families, relationships, and most importantly, ourselves. Life gets hectic and crazy sometimes. We have a million things racing through our minds and we don't have the time or place to let it all out so we keep it bottled up inside.

This creates a backlog of emotions, feelings, things, that we leave un-dealt with. We start to miss the little details along the way, or our mood gets affected because we can't seem to get rid of the negativity festering up inside of us. If we don't have anyone readily available to talk to us, these feelings that have been building inside of us could end up spilling over and affecting our performance at the workplace, at home, whatever it may be.

We are not able to perform these roles at home or at work effectively as a result. This is where the power of journaling comes into play.

Journaling is such an important tool for us to put into paper or into words every single emotion that we are feeling. Every thought that we are thinking. And this works sort of like a cleanse. We are cleansing, decluttering, and unpacking all the things that are jumbled up in our head. By writing these feelings down, we are not only able to keep a clear head, but it also gives us a reference point to come back to if there are any unresolved problems that we feel we need to work on at a later date.

Journaling has worked wonders for me. I've never thought it to be a habit work incorporating into my life because i thought hey, it's another thing for me to do on top of my already hectic day. I don't have time for this. Basically giving 1001 reasons not to do it.

But I came across this life coach that described the wonders of journaling as I am describing to you right now. And I thought. Why not just give it a try.

I did. And it changed my life.

I never realized how powerful journaling could actually be in transforming my state of mind and to always keep me grounded and focused. Everytime I felt that i was distracted, had something I couldn't work through in my mind, I would pick up my ipad and start typing it down in a journal app.

With technology, it has made journaling a much more enjoyable experience for me and one that i can simply do on the fly, anywhere,

anytime. I didn't have to fumble around to find my pen and book, i just opened up the app and started typing away every single feeling and thought.

Journaling helped me see the big picture. It helped me become more aware of the things that are working for me and things that aren't. I was able to focus more on the areas that were bringing more joy in my life and to eliminate the situations and activities that were draining me of my energy and spirit.

Journaling can be anything you want it to be. There are no fixed rules as to how you must journal. Just write whatever comes to your mind. You will be surprised by how much you can learn from yourself. Many a times we forget that we are our best teacher. Other people can't learn our lessons for us, only we can.

So next time you feel sluggish, depressed, unhappy, or even ecstatic and over the moon, write down how and why you got to that place. No judgement, no berating yourself, just pouring your heart and soul onto a piece of paper or into a journaling app. I'll be looking forward to hearing of your transformation from the power of journaling.

Chapter 4:

When To Listen To That Voice Inside Your Head

Everyday we hear a voice in our head telling us things to us. Whether it be a negative voice telling us not to do something, or a positive one that pushes us to try something new, we sometimes forget when and when not to listen to it.

Today I found myself in that very situation. I found myself walking going about my day when I heard a voice telling me that I should go back to my passion, which was to record music, and simply used my voice as the only tool to make music. I had heard this voice many times before, but i always brushed it away because I thought to myself, no one is going to want to hear me sing. Why should anyone? My voice sucks. It's not as good as other people. No one is going to like it. And I am just going to waste my time. Those negative voices always found a way to beat down my positive one to the point where I just gave up listening to them altogether because I figured that I was never going to act on anything out of my fears to do so anyway.

But something happened today that made me listen. Today I felt like it had a point to make and it was trying to get out. and today those goblin voices that usually tried to kill that positive one was silent. I took that

opportunity to head straight down to the nearest electronics store, to buy an expensive mic, and decided that I was going to pursue this venture no matter what. I wanted to do it for myself. I wanted to do it because I didn't want to regret not listening to that inner voice 10-20-30 years down the road. Sure people might still not listen to me sing, but dammit i was going to do it anyway.

It didn't matter to me if only 5 people liked it. It mattered more that I liked it. It mattered more that I overcame myself and finally put music out there that I was proud of.

I bought that mic because I didn't want the excuses in my head to start creeping up on me again. I bought that mic because it gave me no way out. I was already committed. And if I didn't do it I would've just wasted a ton of money. Sometimes in life you have to push yourself and give no reasons to turn back. Because it is always easy just to give up. But when that object is staring at you, sitting and calling out to you, you are going to one to use it.

We all have voices in our heads that tell us to do something crazy but magical in our lives. We shove them aside because we are afraid. We shove them aside because we don't dare to dream. We shove them aside because we think we are not good enough. We fail to realize that we are just one decision away from changing our lives.

Carrie Underwood, for those of you who don't know who she is, she won American Idol in 2005 and became one of the biggest country music

superstars in the world. Did you know that she almost didn't make the trip to audition for American Idol because that goblin voice in her head told her it was a stupid idea to go? In that split second decision where she decided to try anyway, it changed her life forever. She changed the music scene forever. It was crazy to think a girl from a small town could win as many Grammys as she did, but she did.

This is the same dilemma you and I face everyday. We fail to realize that everytime we say no to that crazy idea, we are taking one step back in our lives. Soon we become so used to taking these steps back that we end up taking them forever, failing to achieve anything great in the process. Life is simply one giant list of decisions that we make on a daily basis. Any decision that we choose not to take, is a decision that is either missed, or lost.

Start listening to what that voice inside your head has been telling you to do. Has there been something that has been painfully obvious to you? A voice that has been recurring that you've been shoving aside? Take a pen, write that voice down on apiece of paper. Dig into it and start finding out if you should be taking action on it. You never know what that one decision can do for the rest of your life unless you give it a shot.

Chapter 5:

Understanding Yourself

Today we're going to talk about a topic that hopefully helps you become more aware of who you are as a person. And why do you exist right here and right now on this Earth. Because if we don't know who we are, if we don't understand ourselves, then how can we expect to other stand and relate to others? And why we even matter?

How many of you think that you can describe yourself accurately? If someone were to ask you exactly who you are, what would you say? Most of us would say we are Teachers, doctors, lawyers, etc. We would associate our lives with our profession.

But is that really what we are really all about?

Today I want to ask you not what you do, and not let your career define you, but rather what makes you feel truly alive and connected with the world? What is it about your profession that made you want to dedicated your life and time to it? Is there something about the job that makes you want to get up everyday and show up for the work, or is it merely to collect the paycheck at the end of the month?

I believe that that there is something in each and everyone of us that makes us who we are, and keeps us truly alive and full. For those that dedicate their lives to be Teachers, maybe they see themselves as an educator, a role model, a person who is in charge of helping a kid grow up, a nurturer, a parental figure. For Doctors, maybe they see themselves as healers, as someone who feels passionate about bringing life to someone. Whatever it may be, there is more to them than their careers.

For me, I see myself as a future caregiver, and to enrich the lives of my family members. That is something that I feel is one of my purpose in life. That I was born, not to provide

for my family monetary per se, but to provide the care and support for them in their old age. That is one of my primary objectives. Otherwise, I see and understand myself as a person who loves to share knowledge with others, as I am doing right now. I love to help others in some way of form, either to inspire them, to lift their spirits, or to just be there for them when they need a crying shoulder. I love to help others fulfill their greatest potential, and it fills my heart with joy knowing that someone has benefitted from my advice. From what I have to say. And that what i have to say actually does hold some merit, some substance, and it is helping the lives of someone out there.. to help them make better decisions, and to help the, realise that life is truly wonderful. That is who i am.

Whenever I try to do something outside of that sphere, when what I do does not help someone in some way or another, I feel a sense of dread. I feel that what I do becomes misaligned with my calling, and I drag my feet each day to get those tasks done. That is something that I have realized about myself. And it might be happening to you too.

If u do not know exactly who you are and why you are here on this Earth, i highly encourage you to take the time to go on a self-discovery journey, however long it may take, to figure that out. Only when you know exactly who you are, can you start doing the work that aligns with ur purpose and calling. I don't meant this is in a religious way, but i believe that each and every one of us are here for a reason, whether it may to serve others, to help your fellow human beings, or to share your talents with the world, we should all be doing something with our lives that is at least close to that, if not exactly that.

So I challenge each and everyone of you to take this seriously because I believe you will be much happier for it. Start aligning your work with your purpose and you will find that life is truly worth living.

Chapter 6:

Things That Spark Joy

I'm sure you've heard the term "spark joy", and this is our topic of discussion today that I am going to borrow heavily from Marie Kondo.

Now why do I find the term spark joy so fascinating and why have i used it extensively in all areas of my life ever since coming across that term a few years ago?

When I first watched Marie Kondo's show on Netflix and also reading articles on how this simple concept that she has created has helped people declutter their homes by choosing the items that bring joy to them and discarding or giving away the ones that don't, I began my own process of decluttering my house of junk from clothes to props to ornaments, and even to furniture.

I realised that many things that looked good or are the most aesthetically pleasing, aren't always the most comfortable to use or wear. And when they are not my go to choice, they tend to sit on shelves collecting dust and taking up precious space in my house. And after going through my things one by one, this recurring theme kept propping up time and again. And i subconsciously associated comfort and ease of use with things that spark joy to me. If I could pick something up easily without hesitation to use or wear, they tend to me things that I gravitated to naturally, and

these things began to spark joy when i used them. And when i started getting rid of things that I don't find particularly pleased to use, i felt my house was only filled with enjoyable things that I not only enjoyed looking at, but also using on a regular and frequent basis.

This association of comfort and ease of use became my life philosophy. It didn't apply to simply just decluttering my home, but also applied to the process of acquiring in the form of shopping. Every time i would pick something up and consider if it was worthy of a purpose, i would examine whether this thing would be something that I felt was comfortable and that i could see myself utilising, and if that answer was no, i would put them down and never consider them again because i knew deep down that it would not spark joy in me as I have associated joy with comfort.

This simple philosophy has helped saved me thousands of dollars in frivolous spending that was a trademark of my old self. I would buy things on the fly without much consideration and most often they would end up as white elephants in my closet or cupboard.

To me, things that spark joy can apply to work, friends, and relationships as well. Expanding on the act of decluttering put forth by Marie Kondo. If the things you do, and the people you hang out with don't spark you much joy, then why bother? You would be better off spending time doing things with people that you actually find fun and not waste everybody's time in the process. I believe you would also come out of it being a much happier person rather than forcing yourself to be around people and situations that bring you grief.

Now that is not to say that you shouldn't challenge yourself and put yourself out there. But rather it is to give you a chance to assess the things you do around you and to train yourself to do things that really spark joy in you that it becomes second nature. It is like being fine tuned to your 6th sense in a way because ultimately we all know what we truly like and dislike, however we choose to ignore these feelings and that costs us time effort and money.

So today's challenge is for you to take a look at your life, your home, your friendships, career, and your relationships. Ask yourself, does this thing spark joy? If it doesn't, maybe you should consider a decluttering of sorts from all these different areas in your life and to streamline it to a more minimalist one that you can be proud of owning each and every piece.

Chapter 7:

Top Life regrets of Dying Hospital Patients

The most common regret of dying people is

"I wish I'd had the courage to live a life true to myself, not the life others expected of me."

Why is this such a common dying regret at the end of our lives? And how can you make sure that you don't end up feeling the same way?

How to Be Courageous and Avoid the Biggest Regret

If you're reading this, then you probably have the power to make decisions in your daily life. Rarely, we are forced to live in a way that we don't want to live (thankfully). But somehow, many of us still end up wishing we had lived in a more true way to ourselves.

Here's why I believe this happens:

Anytime I find myself feeling stuck in neutral, it's usually the result of not having a clear target. I find myself doing work without defining what the work should be or hoping for a change without determining the underlying actions that would lead to it. In other words, I'm not clear about what I care about and how I can get there—more on this in a moment.

Here's the result:

If you never draw a line in the sand and clarify what is important to you, then you'll end up doing what's expected of you. When you don't have a clear purpose driving you forward, you default to doing what others approve of. We're not sure what we want, and so we do what we think other people want.

The gray areas in life usually arise when we haven't decided what we believe.

This is the position I think we all find ourselves in from time to time. And it's one reason why I think many of us end up living the life others expect us to live instead of a life that is true to ourselves.

I often think about how I can get better at living with purpose and live an important life instead of an urgent one. When it comes to being clear about what I'm doing and why I'm doing it, I like to use a technique that I call the Bullseye Method.

The Bullseye Method

"A skillful archer ought first to know the mark he aims at and then apply his hand, his bow, his string, his arrow, and his motion accordingly. Our counsels go astray because they are not rightly addressed and have no fixed end. No wind works for the man that has no intended post to sail towards."

— *Michel de Montaigne*

The quote above essentially says: "If you didn't know where the target was located, you would never fire an arrow and expect to hit the bullseye."

And yet, we often live our lives this way. We wake up and face the world day after day (we keep firing arrows), but we focus on everything *except* the bullseye.

For example, if you want to get in shape, then the bullseye is to become the type of person who never misses a workout. That's on target. And yet, many of us spend our time looking for a stronger bow (workout program) or a better arrow (diet plan), or a tighter string (running shoes). Those things matter, but none of them serve you if you're not firing arrows in the right direction.

The Bullseye Method ignores the things we typically focus on, like tactics, resources, or tools. Instead, it focuses on the identity and location of the bullseye. It forces us to be clear about what we want from life.

In other words, forget about how you want to perform or what you want to look like. A bullseye is not "gain 10 pounds of muscle" or "build a successful business." The bullseye is living a life that's on target. It's having a purpose and a clear direction for the actions you will take.

What type of person do you want to become? What type of values do you want to stand for? Which actions do you want to become your habits?

The only way to live a life that is true to you is to have a purpose of organizing your life around. Where is your bullseye located?

Chapter 8:

Why You Are Setting The Wrong Goals

Ever wondered why you are not getting any closer to your goals? Why you keep failing despite having all that effort? Why does someone else seem to be more successful?

Here are some thoughts for you to ponder.

You may have a good set of skills and all the eligibility criteria anyone else has. But you are not yet in the same spot you wished some years ago. Maybe it is not happening for your right now, because your approach to those goals is not correct. Or, maybe your goals are wrong altogether.

Let's say you had a goal to be someone or achieve something someday. But you never had any idea how to! So you started asking why am I not getting the success that I deserve, but never asked yourself, how can I get to that success.

So you might think that you have the right goals to achieve something. But the reality is, that you never had the right goals.

You should have set a single goal a single day. A single goal that you can achieve in a day will help you get on the right train at the right time with a limited effort.

You shouldn't think of the future itself, but the goal that you might achieve someday. Once you have that goal in mind, you shouldn't need a constant reminder every day just to create a scenario of depression and restlessness that won't help you rather strain unnecessary energy.

Once you have the final goal, put it aside and work towards the small goals that you can achieve in real-time with actual small efforts.

Once you have a grasp of these goals, you will find the next goal yourself; a goal that you might have never thought of before.

Just say you want to lose weight and you want to get to your ideal BMI someday. This is a valid and reasonable Goal to achieve. This might prolong your life and increase your self-worth. So you should have a set of regular goals that ultimately lead you to the final goal.

So you want to lose weight, start by reducing fats and carbs in your next meal, and the one after that and the next one.

It will be hard the first time. Maybe the same at the second time. But when you have envisioned the ultimate goal, you will be content with the healthier alternates as well.

Add 5 minutes of exercise the next day, along with the goals of the previous day. You will be reluctant to do it the first time, but when you

see the sweat dripping from your chin, you will see your healthier self in each drop.

Every goal has its process. No matter how much you avoid the process, you will always find yourself at the mercy of mother nature, and nature has always a plan for execution.

Now it's your decision whether to be a part of that process or go down in history with a blank face with no name.

You will always find a way to cheat, but to cheat is another ten steps away from your penultimate goal.

Make it your goal to resist every temptation that makes your day no different than the previous one. Live your life on One day, Monday, Change day principle and you will always find yourself closer to your salvation.

The process of change is mundane. In fact, the process of everything in life is mundane. You have to apply certain steps and procedures for even doing the most basic tasks in your daily life.

Stop procrastinating because you are not fooling anyone else, just yourself. And if you keep fooling yourself, you will be the worst failure in the books of history.

Chapter 9:

The Problem With Immediate Gratification

In today's topic we are going to talk about something that I am sure most of us struggle with every single day, myself included. I hope that by the end of this video, you will be able to make better decisions for yourself to maybe think further ahead rather than trying to get gratification right away.

There will be 5 areas that I want to talk about. Finance, social media, shopping, fitness, and career.

Alright if you're ready let's begin.

Let's start with the one thing that i think most of us will find it hard to resist. Shopping. For many of us, buying things can be a form of happiness. When we want something, our dopamine levels rise, and our attention is solely focused on acquiring that object whatever it may be. The anticipation of getting something is something very exciting and our bodies crave that sense of gratification in getting that product. Shopping can also be a form of distraction, maybe from work or from feeling stressed out. Shopping can also arise from boredom and the desire within us to satisfy our cravings for wanting things begins to consume us. This

creates a real problem because after we attain the item, often we are not satisfied and start looking for the next thing. This creates a never ending cycle of seeking gratification immediately at the expense of our bank account. And we are soon left with a big hole in the wallet without realising it.

Before I talk about the solutions to this problem, i want to address the other 4 areas on the list.

The next one is social media. We tend to gravitate towards social media apps when we want to fill our time out of most probably boredom. At times when we are supposed to be working, instead of blocking out time to stay focused on the task at hand, we end up clicking on Instagram or Facebook, trying to see if there are any new updates to look at provided to us by the algorithm. Social media companies know this and they exploit our feeble nature with this cheap trick. Everytime we try to refresh a page, we seek immediate gratification. And we create within us a terrible habit hundreds of times a day, checking for updates that wastes hours away from our day.

The next area that maybe isn't so common is in the area of fitness. Instead of laying out a long term plan to improve our health and fitness through regular exercise and choosing healthy foods, we tend to want things happening for us immediately. We think and crave losing 10 pounds by tomorrow and set unrealistic targets that easily lets us down. Hence we seek for quick fix solutions that aim to cut short this process. We may end up trying to take slimming pills, or looking for the next

extreme fad or diet to get to our goals quicker. Many of them not ending the right way and can be potentially harmful for our health. For those that cannot control what they eat, in reverse they may seek immediate gratification by bingeing on a fast food meal, ice cream, chocolates, or whatever foods brings them the quickest source of comfort. Many a times at the expense of their weight. All these are also very harmful examples of immediate gratification.

The 4th area I want to talk about is something of bigger importance. And this may not resonate with everybody, but it is about having a career that also focuses on building a side stream of passive income rather than one that focuses on active income. You see active income is static. When we work, we get a pay check at the end of every month. We look forward to that paycheck and that becomes our gratification. But when we stop working, our income stream ceases as well. This desire to keep that paycheck every month keeps us in the jobs that we ate. And we only look towards our jobs as a means to an end, to get that gratification every month in X amounts of dollars. And for many of us who uses shopping as a way to fill the void left by our jobs, we end up using that Hard earned money to gratify ourselves even more, taking up loans and mortgages to buy more and more things. If this is you, you are definitely not alone.

The final area I want to address in the area of finance. And that goes hand in hand with spending money as well. You see for many of us, we fail to see the power that compounding and time has on our finances. When we spend money today instead of saving or investing it, we lose the potential returns that investments can do for our capital. While it may

be fun for us to spend money now to acquire things, it may instead bring us 10x the joy knowing that this $1000 that we have invested could end up becoming $100000 in 30 years when it is time for us to retire. The effects of compounding are astonishing and I urge all of you to take a closer look at investing what you have now as you might be surprised at the amounts of returns you can get in 30-50 years or even sooner.

So where does this lead us in our fight against instant gratification? From the areas we have described, immediate gratification always seem to have a direct negative consequence. When we choose to satisfy our cravings for wanting things fast right now, we feed our inner desires that just keeps craving more. The point is that we will never be satisfied.

If however we take a long-term approach to things and make better decisions to delay our reward, many a times that feeling will return us more than 2 fold than if we had taken it immediately. The problem is that most of us do not possess this sort of patience. Our instinct tells us that now is the best time. But history and the law of life has repeatedly shown us that that is not always true. For many things in our life, things actually gets better with time. The more time you give yourself to heal from a heartbreak, the better it will get. The more time you invest your money, the greater the returns. The more time you spend time on doing something you love, the more happiness you will feel. The more time you put into eating moderately and exercising regularly, the faster you will see your body and health take shape. The more you resist turning on the social media app, the more you will find you won't need its attention after a while. The more time you spend with friends, the deeper the friendship.

The moral of the story in all of this is that giving yourself enough time is the key to success. Trying to get something quick and easy is not always the best solution to everything. You have to put in the time and energy required to see the fruits of your labour. And that is a law that we all have to realise and apply if we want to see true success. Rome isn't built in a day, so why would anything else be? We shouldn't rush through everything that we do expecting fast results and instant gratification.

So i challenge each and everyone of you to take a good look at the areas of your life that you expect fast results and things to happen immediately. See if any of the things that I have mentioned earlier resonates with you and see if you can modify the way you acquire things. I believe that with a little effort, we all can look towards a more rewarding path to success.

Chapter 10:

How To Stop Worrying About Failure

You and me, right now, right here, at this moment are in the best shape we could ever wish to be in. We are alive!

We think that we had a golden past, where we had everything. We had our parents to look out for us, we had friends to share our secrets with. We had a teacher to gossip about. Now It's just a load of responsibilities that we never wanted.

There is always an innate sense of fear in every human being, that He or she is going to fail at something they never wished to fail at. It's normal. But to give up to that fear is not natural, in fact, it is opposite to the very evolutionary trait of every Human Being.

The biggest myth we Humans have ever encountered is that if you stop doing something, you will never get the chance to fail at it. This is the wrong approach to life altogether. How many things can you avoid with this mindset?

Life is an album of events that will challenge you at every corner. You might fail at every other corner, but you will never fail at every single moment in life.

You have dreams you want to pursue, but you fear failing. The only motivation you need is to imagine the bigger image for when you finally get the chance to rise above all.

You don't need to think about what if you fail or what would people say if you never get what you struggled for. Even if you fail, you can walk away with your head held high because you stood for what you believed was right and what you deserved.

Living means doing the things you love to do. If you had to fall here and there to do what you want to achieve in life, then so be it.

Use your brain. Don't let your brain use you. Act like one unit. Don't let your body dictate your actions. Don't let your emotions derail you. Don't let the fear eat your confidence. It doesn't matter if you fail. You will get another chance to prove yourself. Even if you never succeed at a certain thing, there are countless things to achieve that you haven't thought of yet.

The ultimate failure is death itself. Every day you live is a success. Every second you breathe is a second you deserved. Every step you take towards your goal is a part of that success which will be your fate someday.

The best and the fastest way to deal with the fear of doing anything is to do it anyway.

You don't have to feel good to do things that you desire. It is just an illusion of your brain that tricks you and your body to waste yet another moment that could have been well spent.

Train your brain in a way that when you say I want to do this, Your brain never second guesses you. You start doing the thing in the tenth of a second.

It doesn't matter if you don't feel like doing it. Do it anyway. If you train yourself to act in this fashion, You will have the freedom, most people never have.

No man was ever born who had all the riches and never a glimpse of failure in their life. Every rich to ever exist also had a moment or years of struggle to achieve what they have today, but never did they second guess their instincts. Never did they let their fear get the best of them and then the world saw a new era on their hands.

The best advice I can give to buck up someone is simple but very deep; Follow your path no matter what trajectory it might take, just remember, fear the fear itself and you will rise like a phoenix.

Chapter 11:

How To Deal With Feelings of

Unworthiness

Today we're going to talk about a topic that I hope none of you struggle with. But if you do, I hope to bring some light into your life today. Because i too have had to deal with such feelings before, as recently as a year ago actually.

So before we get into the solutions, we must first understand where these feelings of unworthiness comes form. And we must be aware of them before we can make changes in our lives that brings us out of that state of mind.

Let's start with my life, maybe you will understand the kinds of struggles that I had gone through that led me to feeling unworthy.

Just about 3 years ago, I started my entrepreneurial journey, a journey that was full of excitement and curiousity. After being through a couple of internships at a company, i knew the corporate life wasn't really my thing, and i set out on my own path to making money online... To see if i could find a way to have an income without having to work a 9-5 job. The start was rough as I had no experience whatsoever. But over time i started to find a bit of footing and I made some decent income here and

there that would sustain my livelihood for a while. As I was starting to see some success, my "world" came crashing down as something happened with the small business that I had spent almost 3 years building up. And suddenly my income was gone. And I realized I had nothing to show for my 3 years of work. It left me feeling incredibly depressed... Although it doesnt sound like the end of the world to many of you, i felt like i had been set back many years behind my peers who were by then already steadily climbing up the corporate ladder. Feelings that I had made a grave mistake in terms of career choice started creeping up on me. As I tried to figure out what to do with my life, I couldn't help but compare my income to the income that my friends were making. And I felt did feel worthless, and inferior. And I started questioning my whole journey and life choices up till that point.

I started wondering if I was ever going to climb my way back up again, if I would ever figure out how these things actually worked, and all those negative thoughts came day in and out. Eating me alive inside.

It was only after I had done some introspection did I finally started to learn to love myself. And to learn that my journey is unique and mine alone. That I didn't need to, and must not, compare myself to others, did i really start to feel worthy again. I started to believe in my own path, and I felt proud that I had dared to try something that most of my peers were afraid to even try. I found new qualities in myself that I didn't knew I had and I started to forge a new path for myself in my own entrepreneurial journey. Eventually my experience making money online helped me claw my way back up the income ladder, and I have never looked backed since.

For me personally, the one thing that I could take away from my own experience with unworthiness, is to not compare yourself with others. You will never be happy comparing with your peers on income, relationship status, number of friends, number of followers on social media, and all that random things. If you always look at your friends in that way, you will always feel inferior because there will always be someone better than you. Sure you can look to them for inspiration and tips, but never feel that they are superior to you in anyway.. because you are unique in your own beautiful way. You should focus on your own journey and how you can be a better version of yourself. Your peers might have different sets of skills, talents, and expertise, that helped them excel in their fields, but you have your own talents too that you should exploit. You never know what you can achieve until you truly believe in yourself and fully utilise your potential.

For you, your struggle with unworthiness could stem from the way your parents compare you to your siblings, or feeling hopeless trying to find love in this cruel world, or being rejected by companies in your Job applications, or rejection by a potential suitor. These are all valid things that can bring us down. But never let these people tell you what you can or cannot do. Prove to them that you are worthy by constantly improving yourself, mentally, physically, health wise, being emotionally resilient, grow your wisdom, and always love yourself. People cannot love you if you do not love yourself first. That is a quote that i believe very deeply.

No amount of validation from external sources can match the love that I decide to give to myself first.

If you find yourself in situations where you are being bombarded with negativity, whether it be from friends or family, i suggest you take a step back from these people. Find a community where your achievements are celebrated and appreciated, and where you can also offer the same amount of encouragement to others. Join meetup groups in your area with people of similar interests and just enjoy the journey. You will get there eventually if you believe in yourself.

So I challenge each and every one of you to always choose yourself first, look at your own journey as a unique path, different from everybody else, follow your dreams, take action, and never give up. That is the only way to prove to yourself and to the world that you are the most worthy person on the planet.

Chapter 12:

Enjoying The Simple Things

Today we're going to talk about a topic that might sound cheesy, but trust me it's worth taking a closer look at. And that is how we should strive to enjoy the simple things in life.

Many of us think we need a jam packed schedule for the week, month, or year, to tell us that we are leading a very productive and purposeful life. We find ways to fill our time with a hundred different activities. Going to this event, that event, never slowing down. And we find ourselves maybe slightly burnt out by the end of it.

We forget that sometimes simplicity is better than complication. Have you sat down with your family for a simple lunch meal lately? You don't have to talk, you just have to be in each other's company and enjoying the food that is being served in front of you.

I found myself appreciating these moments more than I did running around to activities thinking that I needed something big to be worth my time. I found sitting next to my family on the couch watching my own shows while they watch theirs very rewarding. I found eating alone at my favourite restaurant while watching my favourite sitcom to be equally as enjoyable as hanging out with a group of 10 friends. I also found myself

richly enjoying a long warm shower every morning and evening. It is the highlights of my day.

My point is that we need to start looking at the small things we can do each day that will bring us joy. Things that are within our control. Things that we know can hardly go wrong. This will provide some stability to gain some pleasure from. The little nuggets in the day that will not be determined by external factors such as the weather, friends bailing on us, or irritating customers.

When we focus on the little things, we make life that much better to live through.

Chapter 13:
Having a Balanced Life

Today we're going to talk about how and why you should strive to achieve a balanced life. A balance between work, play, family, friends, and just time alone to yourself.

We all tend to lead busy lives. At some points we shift our entire focus onto something at the expense of other areas that are equally important.

I remember the time when I just got a new office space. I was so excited to work that i spent almost 95% of the week at the office. I couldn't for the life of me figured why i was so addicted to going to the office that I failed to see I was neglecting my family, my friends, my relationships. Soon after the novelty effect wore off, i found myself burnt out, distant from my friends and family, and sadly also found myself in a strained relationship.

This distance was created by me and me alone. I had forgotten what my priorities were. I hadn't realized that I had thrown my life completely off balance. I found myself missing the time I spent with my family and friends. And I found myself having to repair a strained relationship due to my lack of care and concern for the other party.

What you think is right in the moment, to focus on something exclusively at the expense of all else, may seem enticing. It may seem like there is nothing wrong with it. But dig deeper and check to make sure it is truly worth the sacrifice you are willing to make in other areas of your life.

It is easy for us to fall into the trap of wanting to make more money, wanting to work harder, to be career driven and all that. But what is the point in having more money if you don't have anyone to spend in on or spend it with? What's the point in having a nice car or a nice designer handbag if you don't have anyone to show it to?

Creating balance in our lives is a choice. We have the choice to carve out time in our schedule for the things that truly matter. Only when we know how to prioritise our day, our week, our month, can we truly find consistency and stability in our lives.

I know some people might say disagree with what I am sharing with you all today, but this is coming from my personal life experience. It was only after realising that I had broken down all the things I had worked so hard to build prior to this new work venture, that I started to see the bigger picture again.

That I didn't want to go down this path and find myself 30 years later regretting that I had not spent time with my family before they passed away, that I was all alone in this world without someone I can lean my shoulder on to walk this journey with me, that I didn't have any friends that I could call up on a Tuesday afternoon to have lunch with me

because everyone thought of me as a flaker who didn't prioritise them in the their lives before.

Choose the kind of life you want for yourself. If what I have to say resonates with you, start writing down the things that you know you have not been paying much attention to lately because of something else that you chose to do. Whether it be your lover, your friends, a hobby, a passion project, whatever it may be. Start doing it again. The time to create balance is now.

Chapter 14:

How To Worry Less

How many of you worry about little things that affect the way you go about your day? That when you're out with your friends having a good time or just carrying out your daily activities, when out of nowhere a sudden burst of sadness enters your heart and mind and immediately you start to think about the worries and troubles you are facing. It is like you're fighting to stay positive and just enjoy your day but your mind just won't let you. It becomes a tug of war or a battle to see who wins?

How many of you also lose sleep because your mind starts racing at bedtime and you're flooded with sad feelings of uncertainty, despair, worthlessness or other negative emotions that when you wake up, that feeling of dread immediately overwhelms you and you just feel like life is too difficult and you just dont want to get out of bed.

Well If you have felt those things or are feeling those things right now, I want to tell you you're not alone. Because I too struggle with those feelings or emotions on a regular basis.

At the time of writing this, I was faced with many uncertainties in life. My business had just ran into some problems, my stocks weren't doing well, I had lost money, my bank account was telling me I wasn't good enough, but most importantly, i had lost confidence. I had lost the ability

to face each day with confidence that things will get better. I felt that i was worthless and that bad things will always happen to me. I kept seeing the negative side of things and it took a great deal of emotional toll on me. It wasn't like i chose to think and feel these things, but they just came into my mind whenever they liked. It was like a parasite feeding off my negative energy and thriving on it, and weakening me at the same time.

Now your struggles may be different. You may have a totally different set of circumstances and struggles that you're facing, but the underlying issue is the same. We all go through times of despair, worry, frustration, and uncertainty. And it's totally normal and we shouldn't feel ashamed of it but to accept that it is a part of life and part of our reality.

But there are things we can do to minimise these worries and to shift to a healthier thought pattern that increases our ability to fight off these negative emotions.

I want to give you 5 actionable steps that you can take to worry less and be happier. And these steps are interlinked that can be carried out in fluid succession for the greatest benefit to you. But of course you can choose whichever ones speaks the most to you and it is more important that you are able to practice any one of these steps consistently rather than doing all 5 of them haphazardly. But I want to make sure I give you all the tools so that you can make the best decisions for yourself.

Try this with me right now as I go through these 5 steps and experience the benefit for yourself instead of waiting until something bad happens.

The very first step is simple. Just breathe. When a terrible feeling of sadness rushes into your body out of nowhere, take that as a cue to close your eyes, stop whatever you are doing, and take 5 deep breathes through your nose. Breathing into your chest and diaphragm. Deep breathing has the physiological benefit of calming your nerves and releasing tension in the body and it is a quick way to block out your negative thoughts. Pause the video if you need to do practice your deep breathing before we move on.

And as you deep breathe, begin the second step. Which is to practice gratefulness. Be grateful for what you already have instead of what you think u need to have to be happy. You could be grateful for your dog, your family, your friends, and whatever means the most to you. And if you cannot think of anything to be grateful for, just be grateful that you are even alive and walking on this earth today because that is special and amazing in its own right.

Next is to practice love and kindness to yourself. You are too special and too important to be so cruel to yourself. You deserve to be loved and you owe it to yourself to be kind and forgiving. Life is tough as it is, don't make it harder. If you don't believe in yourself, I believe in you and I believe in your worthiness as a person that you have a lot left to give.

The fourth step is to Live Everyday as if it were your last. Ask yourself, will you still want to spend your time worrying about things out of your control if it was your last day on earth? Will you be able to forgive

yourself if you spent 23 out of the last 24 hours of your life worrying? Or will you choose to make the most out of the day by doing things that are meaningful and to practice love to your family, friends, and yourself?

Finally, I just want you to believe in yourself and Have hope that whatever actions you are taking now will bear fruition in the future. That they will not be in vain. That at the end of the day, you have done everything to the very best of your ability and you will have no regrets and you have left no stone unturned.

How do you feel now? Do you feel that it has helped at least a little or even a lot in shaping how you view things now? That you can shift your perspective and focus on the positives instead of the worries?

If it has worked for you today, I want to challenge you to consistently practice as many of these 5 steps throughout your daily lives every single day. When you feel a deep sadness coming over you, come back to this video if you need guidance, or practice these steps if you remember them on your own.

Chapter 15:
Don't Overthink Things

Analysis Paralysis, how many of you have heard of this term before? When a decision is placed before us, many of us try to weigh the pros and cons, over and over again, day and night, and never seem to be able to come up with an answer, not even one week later.

I have been guilty of doing such a thing many times in my life, in fact many in the past month alone. What I've come to realize is that there is never going to be a right decision, but that things always work out in the end as long as it is not a rash decision.

Giving careful thought to any big decision is definitely justified. From buying a car, to a house, to moving to another state or country for work, these are big life-changing decisions that could set the course for our professional and financial future for years to come. In these instances, it is okay to take as much time as we need to settle on the right calculated choice for us. Sometimes in these situations, we may not know the right answer as well but we take a leap of faith and hope for the best and that is the only thing we can do. And that is perfectly okay.

But if we translate the time and effort we take in those big projects into daily decisions such as where to go, what to eat, or who to call, we will find ourselves in a terrible predicament multiple times a day. If we

overthink the simple things, life just becomes so much more complicated. We end up over-taxing our brain to the point where it does not have much juice left to do other things that are truly important.

The goal is to keep things simple by either limiting your choices or by simply going with your gut. Instead of weighing every single pro and con before making a decision, just go. The amount of time we waste calculating could be better spent into energy for other resources.

I have found that i rarely ever make a right choice even after debating hours on end whether I should go somewhere. Because i would always wonder what if i had gone to the other place instead. The human mind is very funny thing. We always seem to think the grass could be greener on the other side, and so we are never contented with what we have in front of us right here right now.

The next time you are faced with a non-life changing decision, simply flip a coin and just go with the one that the coin has chosen for you. Don't look back and flip the coin the other way unless it is truly what your heart wants. We will never be truly happy with every single choice we make. We can only make the most of it.

Chapter 16:
The Trick To Focusing

If you've been struggling with procrastinations and distractions, just not being able to do the things you know you should do and purposefully putting them off by mindlessly browsing social media or the web, then today I'm going to share with you one very simple trick that has worked for me in getting myself to focus.

I will not beat around the bush for this. The trick is to sit in silence for a minute with your work laid out in front of you in a quiet place free from noise or distractions. I know it sounds silly, but it has worked time and time again for me whenever I did this and I believe it will work the same for you.

You see our brains are constantly racing with a million thoughts. Thoughts telling us whether we should be doing our work, thoughts telling us that we should turn on the TV instead, thoughts that don't serve any real purpose but to pull us away from our goal of doing the things that matter.

Instead of being a victim of our minds, and going according to its whims and fancies. Quieting down the mind by sitting in complete silence is a good way to engage ourselves in a deeper way. A way that cuts the mind off completely, to plug ourselves out of the automated thoughts that

don't serve us, and to realign ourselves with our goals and purpose of working.

To do this effectively, it is best that you turn on the AC to a comfortable temperature, sit on your working chair, lay your work out neatly in front of you, and just sit in silence for a moment. What I found that works a step up is to actually put on my noise cancelling headphones, and I find myself disappear into a clear mind. A mind free from noise, distractions, social media, music, and all the possible ways that it can throw me off my focus.

With no noise whatsoever, you will find yourself at complete peace with the world. Your thoughts about procrastination will get crushed by your feelings of serenity and peace. A feeling that you can do anything if you wanted to right now.

Everytime I turned on music or the TV, thinking I needed it as a distraction, my focus always ends up split. I operate on a much lower level of productivity because my mind is in two places. One listening to the TV or music, and the other on my work. I end up wasting more resources of my brain and end up feeling more tired and fatigued quickly than I normally would.

If that sounds familiar to you, well i have been there and done that too. And I can tell you that it is not a sustainable way to go about doing things in the long run.

The power of silence is immense. It keeps us laser focused on the task in front of us. And we hesitate less on every decision.

The next thing I would need you to do is to actually challenge yourself to be distraction free for as long as possible when you first start engaging in silence. Put all your devices on silent mode, keep it vibration free, and do not let notifications suck you back into the world of distractions. It is the number 1 killer of productivity and focus for all of us.

So if u struggle with focusing, I want you to give it a try right. If you know you are distracted there is no harm right here right now to make a choice to give this a shot.

Take out our noise cancelling earphones, turn the ac on, turn your devices off or to silent, lay your work out in front of you, turn up the lights, sit on your chair, close your eyes for a minute, and watch the magic happen.

Chapter 17:
Learning To Trust Others

Today we're going to talk about a topic that has the potential to make or break your working relationships or personal relationships with others.

Trust is something that consistently ranks on the top of relationship goals and it has very good reasons for that. Without trust there is basically no foundation. When you can't trust someone, it basically means that you don't believe they can be left alone without your supervision. If you don't trust someone to do the work you have passed along to them, basically it means you are either micro-managing them all day long or that you might just end up doing the work entirely yourself because you don't believe that they can do a job up to your expectations. How many of you have experienced bosses who are micro-managers like that? Basically it either means that they think they can do a better job or that they don't trust you to do the work at all. And we all hate bosses who are like that. Look into mirror like that now, are you doing that to someone at your workplace now?

If you don't trust someone in a relationship, basically you don't believe that they can't be left to their own devices either if they are out of your sight. You start to worry about what they might do when you're gone. If a partner has cheated on you before, I bet that trust has probably gone out the window and it might take a lot of time and energy to actually start

trusting that person again. If you don't trust a friend, you might not want to tell them secrets for fear that they may go round sharing it with others without your consent. That plays into the concept of trustworthiness as well. It all comes in a package.

To build trust, we have to earn it. With our actions we can show others that we can be trusted with information, secrets, work, to be faithful, and to do right thing at all times. But trust works both ways as well. If we want people to trust us, we must be willing to extend the trust to others as well. If others have displayed level of competency, we need to start learning to trust that they can get the work done without breathing down their necks all times of the day. If however they come back with shoddy work, maybe you might want to keep a closer eye on them before you feel that their work is up to your standards.

Let others prove to you otherwise by giving them the benefit of the doubt first and then assessing their abilities after.

When you show others that you trust them to do a task, more often than not they will feel a sense of urgency and responsibility to get the work done properly and promptly so that they can show you that they are capable. To show you that they are competent and worthy of the trust that you have placed in them. When you can learn to trust can you truly let go and live life freely. Always having to micro-manage others can not only hurt your reputation as "that guy" but also allow you to have more time do focus on areas where your attention is really required. When you

can learn to trust can you truly expand and grow a team, business, company, friendships, and relationships.

I challenge each and everyone of you to learn to trust others and not feel like you have to manage everyone around you to the granular level. If you feel that you have trust issues, for whatever reason, consider working on it or maybe even seeking help. Trust issues usually stems from a past traumatic event or experience that may have impacted your ability to trust again. If so you may one to dig deeper to discover the root of the problem and work through it till the feeling goes away.

Chapter 18:

What To Do When You Feel Like Your Work is not Good Enough

Feeling like your work is not good enough is very common; your nerves can get better of you at any time throughout your professional life. There is nothing wrong with nerves; It tells you that you care about improving and doing well. Unfortunately, too much nervousness can lead to major self-doubt, and that can be crippling. You are probably very good at your work, and when even once you take a dip, you think that things are not like how they seem to you. If this is something you're feeling, then you're not alone, and this thing is known as Imposter Syndrome. This term is used to describe self-doubt and inadequacy. This one thing leaves people fearing that there might be someone who will expose them. The more pressure you apply to yourself, the more dislocation is likely to occur. You create more anxiety, which creates more fear, which creates more self-doubt. You don't have to continue like this. You can counter it.

Beyond Work

If your imposter syndrome affects you at work, you should take some time out and start focusing on other areas of your life. There are chances that there is something in your personal life that is hindering your work

life. This could be anything your sleep routine, friends, diet, or even your relationships. There is a host of external factors that can affect your performance. If there are some boxes you aren't ticking, then there is a high chance of you not performing well at work.

You're Better Than You Think

When you're being crippled by self-doubt, the first thing you have to think about is why you were hired in the first place. The interviewers saw something in you that they believed would improve the business.

So, do you think they would recruit someone who can't do the job? No, they saw your talent, they saw something in you, and you will come good.

When you find yourself in this position, take a moment to write down a few things that you believe led to you being in the role you are now. What did those recruiters see? What did your boss recognize in you? You can also look back on a period of time where you were clicking and felt victorious. What was different then versus now? Was there an external issue like diet, exercise, socializing, etc.?

Check Yourself Before You Wreck Yourself

A checklist might be of some use to you. If you have a list to measure yourself against, then it gives you more than just one thing to judge yourself against. We're far too quick to doubt ourselves and criticize harshly.

The most obvious checklist in terms of work is technical or hard skills, but soft skills matter, too. It's also important to remember that while you're technically proficient now, things move quickly, and you'll reach a point where everything changes, and you have to keep up. You might not ever excel at something, but you can accept the change and adapt to the best of your ability.

It matters that you're hard-working, loyal, honest, and trustworthy. There's more to judge yourself on than just your job. Even if you make a mistake, it's temporary, and you can fix it.

Do you take criticism well? Are you teachable? Easy to coach? Soft skills count for something, which you can look to even at your lowest point and recognize you have strengths.

When you're struggling through a day, week, or even a month, take one large step backward and think about what it is you're unhappy with. What's causing your unhappiness, and how can you improve it?

It comes down to how well you know yourself. If you're clear on what your values are and what you want out of life, then you're going to be fine. If the organization you work for can't respect your values and harness your strengths, then you're better off elsewhere. So, it is extremely important to take time out for that self check-in there could be times you talk to yourself in negative light. Checking in with yourself regularly and not feeding yourself negativity could be one-step forward.

Chapter 19:

Don't Set The Wrong Goals

Most people even though they are the most ambitious ones in their circle do not ever succeed. It's not because they are not capable. It's not because they don't have the effort and hard work for what it takes to be successful. It's certainly not because they haven't had the opportunity.

These people have a pattern for them. These people have all the right energies and all the right tools, but only the wrong motives. These people don't have the right goals.

When you set a goal, many things make you think of them. Most of the time there is an external motivation driving our goals. But why do we need someone else to realize a certain goal?

Yes, this is the biggest reason to set the wrong goals. You don't need some sense of insecurity or jealousy to be motivated and do something that you were never meant to do or become someone who you were never meant to be.

People often portray these feelings as an effort to be extra ambitious towards some pointless thing.

The majority of us don't know what we want in our lives. It is impossible to search for something meaningful when you don't have the faintest idea of anything even closer to what you want.

There are many other things wrong with our approach to setting goals. Most of us procrastinate. We exaggerate things beyond the point of achieving. What we don't realize is that when we are not able to achieve those unrealistic things, we get demotivated and start building fears and doubts. These are the biggest enemies of any success story.

Setting up goals is a process and we need to go through the process. The first step in this process is not to take anything for granted. Because isn't a single worthless thing in life.

Don't underestimate the time and don't rush. Everything happens in a due course and you cannot rush things and expect them to be perfect.

Similarly, you cannot expect to have success without going through a single failure. Failures have a big impact on our personal development. Because failures make us tough and experienced hard-working people that everyone wishes to be. So appreciate every failure and take it as a learning curve to carve out new goals with a different approach.

The final and the most essential step towards an achievable goal is to avoid setting up negative goals. If you want something, don't take the 'The Glass is half empty' approach. If you want to look good, don't aim

that you want to lose fat, just imagine and aim that you want to get healthy.

Negative goals don't mean evil thoughts, but they are the wrong approach towards the right things and this is what forces us to make undesirable and emotionally hurtful goals that don't push you to be good. They rather make you stay demotivated and alone.

The last but not the least thing is to never get hasty and put too much in your basket. Take only what you can use at a certain time and by this rule, you must follow one goal at a time.

Chapter 20:
Get in the Water (Stop wasting time)

Stop wasting time.

If you have something to do, then do it. It is literally that simple. Nobody likes something hanging over their head, it is stressful and pressurising and the longer you leave it, the more of a challenge it is going to be. Just get it done.

It's like getting into cold water. You can start by dipping your big toe in, then walking away and reconsidering, before putting all five of them in, maybe if you are feeling frisky you'll put in your whole foot. It is such a waste. You know you are going to get in the water eventually so you might as well dive in. Otherwise, you will spend 80% of your time drawing out an adjustment that could literally take a few seconds. What is the point? Just dive in and get it over with. Does it take a bigger first-off effort, yes. But it saves you so much time and energy afterwards. After the initial shock and a few seconds of feeling like your skin is trying to shrivel up, you are fine.

If we can do it with cold water then we can do it with that email, project or book. You can dive right into all that research you need to do. Yes, it seems overwhelming, and that first leap is going to be full of questions and discomfort. Mid-air you will probably be asking what you got yourself into but the great thing is that you can't stop mid-air. There's no turning around and floating on the air until you reach solid ground again. You are committed now.

The powerful thing is that 90% percent of your problem is inertia. It is that first step. It's sitting down, firing up your laptop and starting to work. It is getting past the idea that you have so much work to do and just focussing on what you can do right now. But when it comes down it you must realise that there is no work around for that. You cannot not do that first step. Even if it is just a passion you know that passion is going to keep burning you up on the inside until you allow it to burst out. There's no getting past the cold water, there is only getting into it. So you might as well jump. If you are trying to write a book, then sit down and just start typing. Even if you are not even typing words, just sit down for 25 minutes and type away at your keyboard. Then, while you are typing you will realise that you are sitting down and pressing the keys anyways so they may as well say something that make sense. I don't care if what you type is cliché because at this point we are not worried about quality. I don't care how good your form is in your butterfly stroke if you are not even in the water. You just need to get started so that you are moving. And once you are moving you can maximise on your momentum.

Chapter 21:
Work Harder Than Everybody Else

Lacking motivation and lacking the drive and will to get up out of our butts to take that step towards making our dreams a reality is one that everyone struggles with, even me. Every single day, I wake up knowing the plan and the steps i need to take to get where I want to be, but i just can't seem to bring myself to do these necessary tasks. It is as if a wall is blocking my mind from wanting to do the work.

That is until i came across an article highlighting the power of just working harder than everybody else in whatever field or industry you are in. That you just work harder than your peers and success will come to you. And in this article, it tells the story of how Kobe Bryant, Jack Ma, Mark Cuban, and many other highly successful CEOs and entrepreneurs have achieved immense wealth and success just by working harder than anyone else.

While this concept may seem simple, it is certainty not as easy as it sounds. Putting hours more than your peers when they could be out there relaxing, enjoying life, partying and what not is a sacrifice that not everyone is willing to make. But it is this insane work ethic that drives these people to levels of success not seen by their peers.

Kobe Bryant puts this the best. With every 4 hours more that he practices more than his peers on the basketball court everyday, it starts to add up and compound in an incredible way that by the 5th year of training, none of his peers would ever be able to catch up to him no matter how hard they trained before every tournament or championship. By the time comes around, Kobe would have clocked in thousands of hours more than his peers in practice, and what he lacks for in talent (which I doubt is a factor), he makes up for in time on the court. And this time is what makes him one of the best players of all time. Putting him in the league of legends such as Michael Jordan.

The takeaway from Kobe's story is that every minute extra that you put in more than your peers will add up in time and put you leaps and bounds better than your competition. This can be applied to any field, whether it be a real estate career, as an investor, a trader, an athlete. Anything you set aside time for, you will gain the knowledge in time. You just have to start believing in the hours that you put in will pay off eventually.

This is a lesson that I have experienced personally as well. Many of us want to achieve happiness and success fast, today, now, but they forget that greatness isn't built in a day. And I realised that many of the things that i became good at took time to nurture. And the hours i put it only started paying off 2 to 3 years from the day I began embarking on that new journey or career. and I expect that my future endeavours will also take time to grow.

It is the same as watering a baby sprout everyday and giving it sunlight and water consistently, it only starts to grow really big by its 2nd or 3rd year being a healthy plant constantly fed with nutrients to ensure it has the best chance of survival and growth.

I challenge you today to work harder than everybody else around you and have an insane work ethic. Grind it out every single day, put in the hours that is necessary until you succeed and work your face off. Dont settle for anything less and remove distractions that suck out your time. If you outwork everyone every single day, you will eventually come out on top no matter how talented your competition might be. Just give it your best and never give up.

Chapter 22:
Being 100% Happy Is Overrated

Lately I've been feeling as though happiness isn't something that truly lasts. Happiness isn't something that will stay with us very long. We may feel happy when we are hanging out with friends, but that feeling will eventually end once we part for the day. I've been feeling as though expecting to be constantly happy is very overrated. We try to chase this idea of being happy. We chase the material possessions, we chase the fancy cars, house, and whatever other stuff that we think will make us happy. But more often than not the desire is never really fulfilled. Instead, i believe that the feeling accomplishment is a much better state of mind to work towards. Things will never make us happy. We may enjoy the product we have worked so hard for temporarily. But that feeling soon goes away. And we are left wondering what is the next best thing we can aim our sights on. This never-ending chase becomes a repetitive cycle, one that we never truly are aware of but constantly desire. We fall into the trap that finding happiness is the end all-be-all.

What i've come to realise is that most of the time, we are actually operating on a more baseline level. A state that is skewed more towards the neutral end. Neither truly happy, or neither truly sad. And I believe that is perfectly okay. We should allow ourselves to embrace and accept the fact that it is okay to be just fine. Just neutral. Sure it isn't something very exciting, but we shouldn't put ourselves in a place where we expect

to be constantly happy in order to lead a successful life. This revelation came when I realised that every time I felt happy, I would experience a crash in mood the next day. I would start looking at instagram, checking up on my friends, comparing their days, and thinking that they are leading a happier life than I was. I would then start berating myself and find ways to re-create those happy moments just for the sake of it. Just because I thought i needed to feel happy all the time. It was only when I actually sat down and started looking inwards did I realise that maybe I can never truly find happiness from external sources.

Instead of trying to find happiness in things and external factors that are beyond my control, I started looking for happiness from within myself. I began to appreciate how happy I was simply being alone. Being by myself. Not letting other factors pull me down. I found that I was actually happiest when I was taking a long shower, listening to my own thoughts. No music playing, no talking to people, just me typing away on my computer, writing down all the feelings I am feeling, all the thoughts that I am thinking, letting every emotion I was feeling out of my system. I started to realise that the lack of distractions, noise, comparisons with others, free from social media, actually provided me with a clearer mind. It was in those brief moments where I found myself to be my most productive, with ideas streaming all over the place. It was in that state of mind that I did feel somewhat happy. That I could create that state of mind without depending on other people to fulfil it for me.

If any of you out there feel that your emotions are all over the place, maybe it is time for you to sit down by yourself for a little while. Stop

searching for happiness in things and stuff, and sometimes even people. We think it is another person's job to make us happy. We expect to receive compliments, flowers, a kiss, in order to feel happy. While those things are certainly nice to have, being able to find happiness from within is much better. By sitting and reflecting in a quiet space, free from any noise and distractions, we may soon realise that maybe we are okay being just okay. Maybe we don't need expensive jewellery or handbags or fancy houses to make us happy. Maybe we just need a quiet mind and a grateful spirit.

The goal is to find inner peace. To accept life for the way it is. To accept things as the way they are. To be grateful for the things we have. That is what it means to be happy.

Chapter 23:
Dealing With Difficult People

It is inevitable that people will rub us the wrong way as we go about our days. Dealing with such people requires a lot of patience and self-control, especially if they are persistent in their actions towards you over a lengthy period of time.

Difficult people are outside the realm of our control and hence we need to implement strategies to deal with negative emotions should they arise. If you encounter such people frequently, here are 7 ways that you can take back control of the situation.

1. Write Your Feelings Down Immediately

A lot of times we bottle up feelings when someone is rude or unpleasant to us. We may have an urge to respond but in the moment we choose not to. In those circumstances, the next best thing we can do is to write down our feelings either in our journals or in our smartphones as notes.

Writing our feelings down is a therapeutic way to cleanse our thoughts and negative energy. In writing we can say the things we wished we had said, and find out the reasons that made us feel uneasy in the first place. In writing we are also able to clearly identify the trigger points and could work backwards in managing our expectations and feelings around the person. If it is a rude customer, or a rude stranger, we may not be able to

respond for fear or retaliation or for fear of losing our jobs. It is best those situations not to erupt in anger, but take the time to work through those emotions in writing.

2. Tell The Person Directly What You Dislike About Their Attitude

If customer service and retail isn't your profession, or if it is not your boss, you may have the power to voice your opinion directly to the person who wronged you. If confrontation is something that you are comfortable with, don't hesitate to express to them why you are dissatisfied with their treatment or attitude towards you. You may also prefer to clear your head before coming back to confront the person and not let emotions escalate. A fight is the last thing we want out of this communication.

3. Give An Honest Feedback Where Possible On Their Website

If physical confrontation is not your cup of tea, consider writing in a feedback online to express your dissatisfaction. We are usually able to write the most clear and precise account of the situation when we have time to process what went wrong. Instead of handling this confrontation ourselves, the Human Resources team would most likely deal with this person directly, saving you the trouble in the process. Make sure to give an accurate account of the situation and not exaggerate the contents to make the person look extremely in the wrong, although it can be tough to contain our emotions when we are so riled up.

4. Use this Energy To Fuel Your Fire

Sometimes, taking all these energy and intense emotions we feel may fuel our fire to work harder or to prove to others that we are not deserving of their hatred. Be careful though not to take things too far. Remember that ultimately you have the power to choose whether to let this person affect you. If you choose to accept these emotions, use them wisely.

5. Channel This Intense Emotion Into A Craft That Allows You To Release Unwanted Feelings

For those who have musical talents, we may use this negative experience to write a song about it while we are at the heights of our emotions. In those moments the feelings are usually intense, and we all know that emotions can sometimes produce the best works of art. If playing an instrument, writing an article, producing a movie clip, or crushing a sport is something that comes natural to us, we may channel and convert these emotions into masterpieces. Think Adele, Taylor Swift, and all the great songwriters of our generation as an example.

6. Learn To Grow Your Patience

Sometimes not saying anything at all could be the best course of action. Depending on the type of person you are, and the level of zen you have in you, you may not be so easily phased by negativity if you have very high control of your emotions. Through regular meditation and deep breathing, we can let go of these bad vibes that people send our way and

just watch it vanish into a cloud of smoke. Regular yoga and meditation practices are good ways to train and grow your patience.

7. Stand Up For Yourself

At the end of the day, you have to choose when and if you want to stand up for yourself if someone has truly wronged you. We can only be so patient and kind to someone before we snap. Never be afraid to speak your truth and defend yourself if you feel that you have been wrongfully judged. Difficult people make our lives unpleasant but it doesn't mean we should allow them to walk all over us without consequences. You have every right to fight for your rights, even if it means giving up something important in the process to defend it.

Chapter 24:

Discomfort Is Temporary

It's easy to get hopeless when things get a little overwhelming. It's easy to give up because you feel you don't have the strength or resources to continue. But where you stop is actually the start you have been looking for since the beginning.

Do you know what you should do when you are broken? You should relish it. You should use it. Because if you know you are broken, congratulations, you have found your limitations.

Now as you know what stopped you last time, you can work towards mending it. You can start to reinforce the breach and you should be able to fill in the cracks in no time.

Life never repeats everything. One day you feel the lowest and the next might bring you the most unpredictable gifts.

The world isn't all sunshine and rainbows. It is a very mean and nasty place to be in. But what can you do now when you are in it? Nothing? Never!

You have to endure the pain, the stress, the discomfort till you are comfortable with the discomfort. It doesn't make any sense, right? But listen to me.

You have a duty towards yourself. You have a duty towards your loved ones. You are expected to rise above all odds and be something no one has ever been before you. I know it might be a little too much to ask for, but, you have to understand your purpose.

Your purpose isn't just to sit on your back and the opportunities and blessings keep coming, knocking at your door, just so you can give up one more time and turn them down.

Things are too easy to reject and neglect but always get hard when you finally step up and go for them. But remember, every breathtaking view is from the top of a hill, but the trek to the top is always tiring. But when you get to the top, you find every cramp worth it.

If you are willing to put yourself through anything, discomfort and temporary small intervals of pain won't affect you in any way. As long as you believe that the experience will bring you to a new level.

If you are interested in the unknown, then you have to break barriers and cross your limits. Because every path that leads to success is full of them. But then and only then you will find yourself in a place where you are unbreakable.

You need to realize that your life is better than most people out there. You need to embrace the pain because all this is temporary. But when you are finally ready to embrace the pain, you are already on your way to a superior being.

Life is all about taking stands because we all get all kinds of blows. But we always need to dig in and keep fighting till we have found the gems or have found our last breath.

The pain and discomfort will subside one day, but if you quit, then you are already on the end of your rope.

Chapter 25:

It's Okay To Feel Uncertain

We are surrounded by a world that has endless possibilities. A world where no two incidents can predict the other. A realm where we are a slave to the unpredictable future and its repercussions.

Everyone has things weighing on their mind. Some of us know it and some of us keep carrying these weights unknowingly.

The uncertainty of life is the best gift that you never wanted. But when you come to realize the opportunities that lie at every uneven corner are worth living for.

Life changes fast, sometimes in our favor and sometimes not much. But life always has a way to balance things out. We only need to find the right approach to make things easier for us and the ones around us.

Everyone gets tested once in a while, but we need to find ways to cope with life when things get messy.

The worst thing the uncertainty of life can produce is the fear in your heart. The fear to never know what to expect next. But you can never let fear rule you.

To worry about the future ahead of us is pointless. So change the question from 'What if?' to 'What will I do if.'

If you already have this question popping up in your brain, this means that you are already getting the steam off.

You don't need to fear the uncertain because you can never wreck your life in any such direction from where there is no way back.

The uncertainty of life is always a transformation period to make you realize your true path. These uncertainties make you realize the faults you might have in your approach to things.

You don't need to worry about anything unpredictable and unexpected because not everything is out of your control every time. Things might not happen in a way you anticipated but that doesn't mean you cannot be prepared for it.

There are a lot of things that are in your control and you are well researched and well equipped to go around events. So use your experience to do the damage control.

Let's say you have a pandemic at your hand which you couldn't possibly predict, but that doesn't mean you cannot do anything to work on its effects. You can raise funds for the affected population. You can try to find new ways to minimize unemployment. You can find alternate ways to keep the economy running and so on.

Deal with your emotions as you cannot get carried away with such events being driven by your feelings.

Don't avoid your responsibilities and don't delay anything. You have to fulfill every task expected of you because you were destined to do it. The results are not predetermined on a slate but you can always hope for the best be the best version of yourself no matter how bad things get.

Life provides us with endless possibilities because when nothing is certain, anything is possible. So be your own limit.

Chapter 26:
Saying Yes To Things

Today we're going to talk about why saying yes can be a great thing for you and why you should do so especially in social invites.

Life you see is a funny thing. As humans, we tend to see things one dimensionally. And we tend to think that we have a long life ahead of us. We tend to take things for granted. We think we will have time to really have fun and relax after we have retired and so we should spend all our efforts and energy into building a career right now, prioritising it above all else. When faced with a choice between work and play, sometimes many of us, including myself choose work over social invites.

There were periods in my life that i routinely chose work over events that it became such a habit to say no. Especially as an entrepreneur, the interaction between colleagues or being in social events is almost reduced to zero. It became very easy and comfortable to live in this bubble where my one and only priority in life is to work work work. 24 hours, 7 days a week. Of course, in reality a lot of time was wasted on social media and Netflix, but u know, at least i could sort of pretend that i was kind of working all day. And I was sort of being productive and sort of working towards my goals rather than "wasting time on social events". That was what I told myself anyway.

But life does not work that way. As I prioritised work over all else, soon all the social invite offers started drying up. My constant "nos" were becoming evident to my social circle and I was being listed as perpetually unavailable or uninterested in vesting time or energy into any friendships or relationships. And as i retreated deeper and deeper into this black hole of "working remotely" i found myself completely isolated from new experiences and meeting new people, or even completely stopped being involved in any of my friend's lives.

I've successfully written myself out of life and I found myself all alone in it.

Instead of investing time into any meaningful relationships, I found that my closest friends were my laptop, tablet, phone, and television. Technology became my primary way of interacting with the world. And I felt connected, yet empty. I was always plugged in to wifi, but i lived my life through a screen instead of my own two eyes. My work and bedroom became a shell of a home that I spent almost all my time, and life just became sort of pointless. And I just felt very alone.

As I started to feel more and more like something was missing, I couldn't quite make out what it was that led me to this feeling. I simply though to myself, hey I'm prioritising work and my career, making money is what the internet tells me I should do, and not having a life is simply part of the price you have to pay... so why am I so incredibly unhappy?

As it turns out, as I hope many of you have already figured out at this point, that life isn't really just about becoming successful financially.

While buying a house, getting a car, and all that good stuff is definitely something that we should strive towards, we should not do so at the expense of our friends. That instead of saying no to them, we should start saying yes, at least once in a while. We need to signal to our friends that hey, yes even though I'm very busy, but I will make an effort to carve out time for you, so that you know I still value you in my life and that you are still a priority.

We need to show our friends that while Monday may not work for us, that I have an opening maybe 2 weeks later if you're still down. That we are still available to grow this friendship.

I came to a point in my life where I knew something had to change. As I started examining my life and the decisions I had made along the way with regards to my career, I knew that what I did wrong was saying no WAAAAAY too often. As I tried to recall when was the last time I actually when I went out with someone other than my one and only BFF, I simply could not. Of the years that went by, I had either said that I was too busy, or even on the off chances that I actually agreed to some sort of meetup, I had the habit of bailing last minute on lunch and dinner appointments with friends. And I never realized that i had such a terrible reputation of being a flaker until I started doing some serious accounting of my life. I had become someone that I absolutely detested without even realising it. I have had people bail on me at the very last minute before, and I hated that feeling. And whenever someone did that to me, I generally found it difficult to ask them out again because I felt that they weren't really that interested in meeting me anyway. That they didn't even

bother to reschedule the appointment. And little did I know, I was becoming that very same person and doing the very thing that I hate to my friends. It is no wonder that I started dropping friends like flies with my terrible actions.

As I came to this revelation, I started panicking. It was as if a truck had hit me so hard that I felt that I was in a terrible accident. That how did I let myself get banged up to that extent?

I started scrolling through my contact lists, trying to find friends that might still want to hang out with me. I realized that my WhatsApp was basically dry as a desert, and my calendar was just work for the last 3 years straight with no meaningful highlights, no social events worth noting.

It was at this point that I knew I had made a huge mistake and I needed to change course immediately. Salvaging friendships and prioritising social activities went to the top of my list.

I started creating a list of friends that I had remotely any connection to in the last 5 years and I started asking them out one by one. Some of my friends who i had asked out may not know this, but at that point in my life, i felt pretty desperate and alone and I hung on to every meeting as if my life depended on it. Whilst I did manage to make some appointments and met up with some of them. I soon realized that the damage had been done. That my friends had clearly moved on without me... they had formed their own friends at work and elsewhere, and I was not at all that important to have anymore. It was too little too late at that point and

there was not much I could do about it. While I made multiple attempts to ask people out, I did not receive the same offers from people. It felt clearly like a one-way street and I felt that those people that I used to call friends, didn't really see me as one. You see growing a friendship takes time, sometimes years of consistent meetups before this person becomes indispensable in your life. Sharing unique experiences that allow your friends to see that you are truly vested in them and that you care about them and want to spend time with them. I simply did not give myself that chance to be integrated into someone's life in that same way, I did not invest that time to growing those friendships and I paid the price for it.

But I had to learn all these the hard way first before I can receive all the good that was about to come in the future.

Chapter 27:

Planning Ahead

The topic that are going to discuss today is probably one that is probably not going to apply to everybody, especially for those who have already settled down with a house, wife, kids, a stable career, and so on. But i still believe that we can all still learn something from it. And that is to think about planning ahead. Or rather, thinking long term.

You see, for the majority of us, we are trained to see maybe 1 to 2 years ahead in our lives. Being trained to do so in school, we tend to look towards our next grade, one year at a time. And this system has ingrained in us that we find it hard to see what might and could happen 2 or 3 years down the road.

Whilst there is nothing wrong with living life one year at a time, we tend to fall into a short term view of what we can achieve. We tell ourselves we must learn a new instrument within 1 year and be great at it, or we must get this job in one year and become the head of department, or we must find our partner and get married within a short amount of time. However, life does not really work that way, and things actually do take much longer, and we do actually need more time to grow these small little shoots into big trees.

We fail to see that we might have to give ourselves a longer runway time of maybe 3-5 or even 10 years before we can become masters in a new instrument, job, relationship, or even friendships. Rome isn't built in a day and we shouldn't expect to see results if we only allow ourselves 1 year to accomplish those tasks. Giving ourselves only 1 year to achieve the things we want can put unnecessary pressure on ourselves to expect results fast, when in reality no matter how much you think u think rushing can help you achieve results faster, you might end up burning yourself out instead.

For those short term planners, even myself. I have felt that at many stages in my life, i struggle to see the big picture. I struggle to see how much i can achieve in lets say 5 years if i only allowed myself that amount of time to become a master in whatever challenge i decide to take on. Even the greatest athletes take a longer term view to their career. They believe that if they practice hard each day, they might not expect to see results in the first year, but as their efforts compound, by the 5th year they would have already done so much practice that it is statistically impossible not to be good at it.

And when many of us fall into the trap of simply planning short term, our body reacts by trying to rush the process as well. We expect everything to be fast fast fast, and results to be now now now. And we set unrealistic goals that we cannot achieve and we beat ourselves up for it come December 31st.

Instead i believe many of us should plan ahead by giving ourselves a minimum of 2.5 years in whatever task we set to achieve, be it an income goal, a fitness goal, or a relationship goal. 2.5 years is definitely much more manageable and it gives us enough room to breathe so that we don't stress ourselves out unnecessarily. If you feel like being kinder to yourself, you might even give yourselves up to 5 years.

And again the key to achieving success with proper long term planning is Consistency. If you haven't watched my video on consistency do check it out as i believe it is one of the most important videos that I have ever created.

I believe that with a run time of 5 years and consistency in putting the hours every single day, whether it is an hour or 10 hours, that by the end of it, there is no goal that you cannot achieve. And we should play an even longer game of 10 years or so. Because many of the changes we want to make in life should be permanent and sustainable. Not a one off thing.

So I challenge each and everyone of you today to not only plan ahead, but to think ahead of the longevity of the path that you have set for yourself. There is no point rushing through life and missing all the incredible sights along the way. I am sure you will be a much happier person for it.

Chapter 28:

How To Improve Your

Communication Skills

Today we're going to talk about a topic that could help you be a better communicator with your spouse, your friends, and even your colleagues and bosses. Being able to express yourself fluently and eloquently is a skill that is incredibly important as it allows us to express our thoughts and ideas freely and fluently in ways that others might understand.

When we are able to communicate easily with others, we are able to build instant rapport with them and this allows us to appear better than we actually are. We may be able to cover some of our flaws if we are able to communicate our strengths better.

So how do we actually become better communicators? I believe that the easiest way to begin is to basically start talking with more people. It is my experience that after spending much time on my own without much social interaction, that i saw my standard of communication dropped quite drastically. You see, being able to talk well is essentially a social skill, and without regular practice and use, you just simply can't improve it. I saw that with irregular use of social interaction, the only skill that actually improved for me was texting. And we all know that texting is a very

impersonal way to communicate and does not actually translate to real world fluency in person to person conversations.

Similarly, watching videos on communication and reading tips and tricks really does not help at all unless you apply it in the real world. And to have regular practice, you need to start by either inviting all your friends out to a meal so that you can strike up conversations and improve from there, or by maybe joining a social interaction group class of sorts that would allow you to practice verbal communication skills. If u were to ask me, I believe that making the effort to speak to your friends and colleagues is the best way to begin. And you can even ask them for feedback if there are any areas that they find you could improve on. Expect genuine feedback and criticisms as they go if you hope to improve, and do not take them personally.

It is with my personal experience that i became extremely rusty when it came to talking to friends at one point in my life, when i was sort of living in isolation. I find it hard to connect even with my best friend, and i found it hard to find topics to discuss about, mainly because i wasn't really living much to begin with, and there was nothing i was experiencing in life that was really worth sharing. If you stop living life, you stop having significant moments, you stop having problems that need solving, and you stop having friends that needs supporting. I believe the best way is to really try to engage the person you are talking to by asking them very thoughtful questions and by being genuinely interested in what they have to say. Which also coincidentally ties into my previous video about being

a good listener. which you should definitely check out if you haven't done so already.

Being a good listener is also a big part of being a good communicator. The other part being able to respond in a very insightful way that isn't patronising. We can only truly connect with the person we are talking to if we are able to first understand on an empathetic level, what they are going through, and then to reply with the same level of compassion and empathy that they require of us.

With colleagues and bosses, we should be able to strike up conversations that are professional yet natural. And being natural in the way we communicate takes practice from all the other social interactions that precede us.

I believe that being a good communicator really takes time and regular practice in order for it to come one day and just click for us. For a start, just simply try to be friendly and place yourself out of your comfort zone, only then can you start to see improvements.

I challenge each and everyone of you today who are striving to be better communicators to start asking out your friends and colleagues for coffees and dinners. Get the ball rolling and just simply start talking. Over time, it will just come naturally to you. Trust me.

Chapter 29:

How To Crush Your Goals This Quarter

Some people find it very hard to achieve their goals, but luckily, there is a method waiting to be used. The quarter method divides the year into four parts of 90-days; for each part, you set some goals to crush. The rest of the year has gone, and so have the three quarters; now it is time to prepare for the fourth quarter. 1st October is one of the most critical days in the life of a person who sets his goals according to the quarter. It is the benchmark representing the close of the third quarter and the beginning of the fourth quarter. It is the day when you set new goals for the upcoming three months; if somehow your third-quarter dreams were not crushed, then you can stage a comeback so you wouldn't be left behind forever. But how to achieve your fourth-quarter goals?

1st October may bring the start of a quarter, but it also ends another quarter; it is the day when you focus on your results. Have you achieved the goals you set for the third quarter? If not, then prepare yourself to hear the hard truth. Your results reflect your self-esteem; if you believe in yourself, then you would achieve your goals. If you are not satisfied with your results, think, is this what you had in mind? If no, then having small visions can never lead to a more significant impact. Limiting beliefs

will never give you more than minor and unimpressive results. Your results tell you about your passion for your work; if you are not passionate about your work, you would have poor outcomes. We all have heard the famous saying, " work in silence and let your success make the noise," but what does this mean? It means that your results will tell everyone about your hard work. If your results are not satisfactory, you know that the problem is your behavior towards your work.

When setting goals for the future, one needs to accept the facts; what went wrong that put you off the track? The year is 75% complete, and if you still haven't crushed your goals, you need to accept that it is your fault. If you blame these failures on your upbringing, your education, or any other factor than yourself, then you are simply fooling yourself because it is all dependent on you. When you don't achieve what you wanted to in nine months, you must have figured the problem; it can be any bad habit you are not willing to give up or the strategies you are implying. If you pretend your habits, attitude, and approach are just fine, you are just fooling yourself, not anyone else. This benchmark is the best time to change the old bad habits and try forming some new strategies.

To finish the year with solid results, you need to get serious; the days of dissatisfied results are gone, now it is time to shine some light on your soul and determine what you are doing wrong, what habits are working in your favor, and which ones are not. Then you can decide which habits to give up on, which habits to improve, and which ones to keep. Once you have sorted this out, prioritize your goals and set some challenging

destinations to avoid getting bored or feeling uninterested. When setting deadlines, try to set enforceable deadlines.

Confusion can lead to poor results, so sit back and think about the goals that I should not pursue. This is called understanding goal competition; the goals you set are competing for your time. Actual peak performance comes from understanding which goals to pursue and which not to seek. And when you complete a plan, don't just rush into the process of crushing the next goal; allow yourself to celebrate your win and feel the happiness of the goal finally getting destroyed by you.

Chapter 30:
Overcoming Your Fears

Today we're going to talk about the topic of fears. What fear is and how we can overcome it. Now before we dive into it, let us just take a brief moment to think of or right down what our greatest fears are right now.

Whether it be taking the next step in your relationship, fear of the unknown, fear of quitting your job and not finding another one, fear or death, fear of illnesses, whatever fear that jumps out at you and is just eating at you at the back of your mind, i want you to remember that fear as we go through this video.

So what is fear exactly? Whilst there are many definitions of fear out there, I'm going to take, as usual, my spin on things. And to me fear is simply a negative feeling that you assign to usually a task that you really don't want to do. And most of the time, the fear is of the unknown, that you can't visualise what is going to happen next. You don't know whether the outcome will be good or bad, and you don't know whether it is the right move to make. So this trio of thoughts keep circling round and round and eventually you just decide that you are not going to take any action on it and you just shove it to one side hoping that it goes away. And whilst you may do that temporarily, sometimes even for months, one day you are going to have to come face to face with it again. And

when that day comes, you will either be paralysed again or you may again put it off to a later date.

We procrastinate on our fears because we want a sure thing. We want to know what will happen next, and we fear what we don't know.

Now for the fears that we are talking about today, it is something that will affect your life if u don't take action. If it is like a fear of bungee jumping or sky driving, sure that fear is physical and very real, but also you can make a choice not to do it and your problem is solved. It will not affect your life in a negative way if u don't do it.

But if it is a fear of a career switch because you already hate your job so much and are totally miserable, that is a fear that you should do your best to try and address as soon as possible.

So what can and should you do about these sorts of fears? The answer for this one is not going to be that difficult. Simply think of the consequences of not conquering your task and how much it might prevent you from moving forward in life and you have got your answer.

When the pain associated with not accomplishing the task becomes greater than the fear we assign to it, it is the tipping point that we need to finally take that action. But instead of waiting to get to that excruciating pain, we can visualise and project what it could potentially feel like if we don't do it now and the pain we might feel at a later day, say 1 year from now, when we have wasted another full year of our life not taking that

leap of faith, the time we have burned, the time we can never get back, and the opportunity cost of not taking action now, we might just decide that we don;t want to wait until that day comes and face that huge amount of regret that we should've done something a lot sooner.

And what we need to simply do is to just take action. Taking action is something you will hear from all the gurus you will find out there. When faced with a fear or challenge, instead of wondering what dangers lurk in the unknown, just take action and let the experience tell you whether it was indeed the right or wrong decision. Do you necessary homework and due diligence beforehand and take that calculated step forward instead of procrastinating on it. Life is too short to be mucking around. Just go for it and never live your life in fear or regret ever again.

I challenge each and everyone of you to go through the list that we have created at the start of the video. The one that you have been most fearful of doing. And i want you to assess the pros and cons of each fear that you have written down. If there are more pros than cons, i want you to set a deadline for yourself that you will take action on it. And that deadline is today. Don't waste precious time worrying and instead spend more time doing.

Chapter 31:

Take Ownership of Yourself

What belongs to you but is used by other people more than you?

Your name.

And that's okay. People can use your name. But you must never allow yourself to lose ownership of you. In fact, you need to be incredibly conscious of taking ownership of everything that you are. And I do mean everything. Those few extra pounds, the nose you think is too big, your ginger hair or freckled skin. Whatever it is that you are insecure about, it's time that you showed up and took ownership. Because the moment you do your world will change.

But what does that look like? Why does it matter?

If someone parks a limo in the road outside your house, hands you the keys and tells you it is yours, what would you do? You're not just gonna put the keys in the ignition and leave it in the road. You are going to put that thing in a garage and get it insured. You will make sure that it is in a place where it is safe from weather and your jealous neighbour. Those are the things that you do when you take ownership of something. You make sure that they are protected because you value them. Then when you drive around town you don't look around as if you've stolen the thing. You drive with style and confidence. You are bold and comfortable because it belongs to you. *That* is what ownership looks like.

Now I know what you're thinking. That's easy to do with a limo, but I what I have is the equivalent of a car built before world war two. But the

beautiful thing about ownership is that it does not depend on the object. It is not the thing being owned that you have to worry about, all you have to do is claim it. You've seen teenagers when they get their first car. Even if it is an old rust-bucket they drive around beaming with pride. Why? Because they know that what they have is theirs. It belongs to them and so they take ownership of it.

You have to do the same. You must take ownership of every part of you because in doing so you will keep it secure. You no longer have to be insecure about your weight if you know that that is where you are at right now. That doesn't mean you don't work for change though. It doesn't give you an excuse for stagnancy. You take accountability for your change and growth as much as you do for your present state. But in taking ownership you work towards polishing your pride, not getting rid of your low self-esteem. The difference may sound semantic, but the implications are enormous. The one allows you to work towards something and get somewhere good. The other makes it feel like you are just running away from something. And when you are running away then the only direction that matters is away – even if that means you run in circles.

Make a change today. Own yourself once more and be amazed at the rush that comes with it. With ownership comes confidence.

Chapter 32:

The Difference Between Professionals and Amateurs

It doesn't matter what you are trying to become better at. If you only do the work when you're motivated, then you'll never be consistent enough to become a professional. The ability to show up every day, stick to the schedule, and do the work, especially when you don't feel like it — is so valuable that you need to become better 99% of the time. I've seen this in my own experiences. When I don't miss workouts, I get in the best shape of my life. When I write every week, I become a better writer. When I travel and take my camera out every day, I take better photos. It's simple and powerful. But why is it so difficult?

The Pain of Being A Pro

Approaching your goals — whatever they are — with the attitude of a professional isn't easy. Being a pro is painful. The simple fact of the matter is that most of the time, we are inconsistent. We all have goals that we would like to achieve and dreams that we would like to fulfill, but it doesn't matter what you are trying to become better at. If you only do the work when it's convenient or exciting, then you'll never be consistent enough to achieve remarkable results.

I can guarantee that if you manage to start a habit and keep sticking to it, there will be days when you feel like quitting. When you start a business, there will be days when you don't feel like showing up. When you're at the gym, there will be sets that you don't feel like finishing. When it's time to write, there will be days that you don't feel like typing. But stepping up when it's annoying or painful or draining to do so, that's what makes the difference between a professional and an amateur.

Professionals stick to the schedule. Amateurs let life get in the way. Professionals know what is important to them and work towards it with purpose. Amateurs get pulled off course by the urgencies of life. **You'll Never Regret Starting Important Work.**

Some people might think I'm promoting the benefits of being a workaholic. "Professionals work harder than everyone else, and that's why they're great." That's not it at all.

Being a pro is about having the discipline to commit to what is important to you instead of merely saying something is important to you. It's about starting when you feel like stopping, not because you want to work more, but because your goal is important enough to you that you don't simply work on it when it's convenient. Becoming a pro is about making your priorities a reality.

There have been many sets that I haven't felt like finishing, but I've never regretted doing the workout. There have been many articles I

haven't felt like writing, but I've never regretted publishing on schedule. There have been many days I've felt like relaxing, but I've never regretted showing up and working on something important to me.

Becoming a pro doesn't mean you're a workaholic. It means that you're good at making time for what matters to you — especially when you don't feel like it — instead of playing the role of the victim and letting life happen to you.

Chapter 33:

How To Start Working Immediately

"There is only one way for me to motivate myself to work hard: I don't think about it as hard work. I think about it as part of making myself into who I want to be. Once I've chosen to do something, I try not to think so much about how difficult or frustrating or impossible that might be; I just think about how good it must feel to be that or how proud I might be to have done that. Make hard look easy." - Marie Stein.

Motivation is somewhat elusive. Some days you feel it naturally, other days you don't, no matter how hard you try. You stare at your laptop screen or your essay at the desk, willing yourself to type or write; instead, you find yourself simply going through the motions, not caring about the work that you're producing. You're totally uninspired, and you don't know how to make yourself feel otherwise. You find yourself being dissatisfied, discouraged, frustrated, or disappointed to get your hands on those long-awaited tasks. While hoping for things to change and make our lives better overnight magically, we waste so much of our precious time. Sorry to burst your bubble, but things just don't happen like that. You have to push yourself off that couch, turn off the phone, switch off Netflix and make it happen. There's no need to seek anyone's permission or blessings to start your work.

The world doesn't care about how tired you are. Or, if you're feeling depressed or anxious, stop feeling sorry for yourself while you're at it. It doesn't matter one bit. We all face obstacles and challenges and struggles throughout our days, but how we deal with those obstacles and difficulties defines us and our successes in life. As James Clear once said, "Professionals stick to the schedule, amateurs let life get in the way. Professionals know what is important to them and work towards it with purpose; amateurs get pulled off course by the urgencies of life."

Take a deep breath. Brew in your favorite coffee. Eat something healthy. Take a shower, take a walk, talk to someone who lifts your energy, turn off your socials, and when you're done with all of them, set your mind straight and start working immediately. Think about the knowledge, the skill, the experience that you'll gain from working. Procrastination might feel good but imagine how amazing it will feel when you'll finally get your tasks, your work done. Don't leave anything for tomorrow. Start doing it today. We don't know what tomorrow might bring for us. If we will be able even to wake up and breathe. We don't know it for sure. So, start hustling today. You just need that activation energy to start your chain of events.

Start scheduling your work on your calendar and actually follow it. We may feel like we have plenty of time to get things done. Hence, we tend to ignore our work and take it easy. But to tell you the truth, time flickers by in seconds. Before you know it, you're already a week behind your deadline, and you still haven't started working yet. Keep reminding yourself as to why you need to do this work done. Define your goals and

get them into action. Create a clear and compelling vision of your work. You only achieve what you see. Break your work into small, manageable tasks so you stay motivated throughout your work procedure. Get yourself organized. Unclutter your mind. Starve your distractions. Create that perfect environment so you can keep up with your work until you're done. Please choose to be successful and then stick to it.

You may feel like you're fatigued, or your mind will stop producing ideas and creativity after a while. But that's completely fine. Take a break. Set a timer for five minutes. Force yourself to work on the thing for five minutes, and after those five minutes, it won't feel too bad to keep going. Make a habit of doing the small tasks first, so they get out of the way, and you can harness your energy to tackle the more significant projects.

Reward yourself every time you complete your work. This will boost your confidence and will give you the strength to continue with your remaining tasks. Don't let your personal and professional responsibilities overwhelm you. Help yourself stay focused by keeping in mind that you're accountable for your own actions. Brian Roemmele, the Quora user, encourages people to own every moment, "You are in full control of this power. In your hands, you can build the tallest building and, in your hands, you can destroy the tallest buildings."

Start surrounding yourself with people who are an optimist and works hard. The saying goes, you're the average of the five people you hang out with the most. So, make sure you surround yourself with people who push you to succeed.

No matter how uninspired or de-motivating it may seem, you have to take that first step and start working. Whether it's a skill that you're learning, a language that you want to know, a dance step that you wish to perfect, a business idea that you want to implement, an instrument that you want to master, or simply doing the work for anyone else, you should do it immediately. Don't wait for the next minute, the next hour, the next day, or the following week; start doing your stuff. No one else is going to do your work for you, nor it's going to be completed by itself. Only you have the power to get on with it and get it done. Get your weak spots fixed. In the end, celebrate your achievements whether it's small or big. Imagine the relief of not having that task up on your plate anymore. Visualize yourself succeeding. It can help you stay to stay focused and motivated and get your work done. Even the worst tasks won't feel painful, but instead, they'll feel like a part of achieving something big.

Remember, motivation starts within. Find it, keep it and make it work wonders for you.

Chapter 34:
7 Ways To Know When It's Time To Say Goodbye To The Past

Holding on to someone or something and fearing to let go is a problem that many of us will struggle with at some point or another. Be it a partner, career, or item, a history has been built around that and we find it hard to move on and leave this treasured piece behind.

Whether it be a 6months or 10 years, it can be hard for us to come to terms with letting go because we have invested so much time, energy, and soul, into it. Governed by emotions, we hold on to them even though it may no longer bring us happiness or joy.

Whatever the reasons are, here are 7 ways that can help you say goodbye to the past and invite better things into your life:

2. You've Drag things For Way Too Long

If it's a career that you're holding on to, you may feel that you've invested a lot of effort and energy in it, waiting for the time that you will get promoted. But the days come and go, months turn into years, and you find yourself a decade later wondering what happened. Letting things

drag on is no way to live life. Time is precious and every moment we waste is a moment we can never get back.

3. You Know It's Time

People may tell us we're happy and that we should be so lucky to have this job or that person in our lives, but no one can hide the unhappiness that is festering within us. Deep down in our hearts, we understand ourselves more than any other people ever would. And we know, subconsciously, if it's time to move on and let go of the past. If you are unsure, do some soul-searching. Find a time to sit by yourself quietly, or go for a retreat on your own. Sort out your feelings and bring some clarity to yourself.

4. It No Longer Brings You Joy

With a person who we have spent so much energy being a relationship with over the years, it can be hard to come to terms with the reality that he or she no longer makes you feel happy or loved anymore. Being in a constant state of unhappiness is no way to live our lives. We have every power in us to make decisions that serves us rather than hinder us. Acknowledge and accept these feelings of unhappiness. Use it as fuel to make that important decision that you know you must make.

5. You Are Holding On Out of Fear

Many a times we hold out on ending that relationship with something because we live in a constant state of fear. Career-wise we may resign ourself to the fate that things are just the way it is and we are afraid that we may never find another job again. So we hold on to that false sense of security and just drag your feet till retirement. Relationship wise, we hold on to them because we fear we may never find someone else again. So we let fear keep us in these places, feeling more and more trapped in the process.

6. You're Afraid of the Unknown

It is human nature to be afraid of the unknown. If we cannot see a clear path ahead, most of us would not dare to travel down that road. We don't know if the grass will be greener on the other side if we quit our jobs, and we don't know what the dating world will be like after being out of it for so long. We lose confidence in believing the unknown is a magical place and that wonderful things can happen there if we let ourselves take the leap of faith. That was how we got to where we were in the first place before we realized it no longer served us anymore.

7. You're Ready For Change

This is similar to the second point about knowing it's time with one key difference - you know that you ready for a new phase of life. Having the urge to intact change in your life, you believe that you don't want to be stuck in whatever situation you are in anymore. You desperately want to

make things better. Embrace these feelings and start taking strong action to force change to happen for you.

8. You Know You Deserve Happiness

Happiness has to be earned. Happiness doesn't just happen to you. If you know you deserve to be happy, and that the current thing you are holding on to only brings you sorrow, it is time to let it go. Only when you let go of what's holding you down can you make room for better and brighter things. Putting yourself out there in the face of trials and errors is the only way you can find what you are truly looking for. Demand happiness and expect it to happen to you.

Conclusion
Saying goodbye to the past is not easy, and not everyone has the courage or strength to do it. You can either choose to live in fear, or you can choose to live a brave life. It is time to make that critical decision for yourself at this crossroad right now. Only one choice can bring you the life that you truly desire. So choose wisely.

Lightning Source UK Ltd.
Milton Keynes UK
UKHW020713310122
397970UK00007B/163